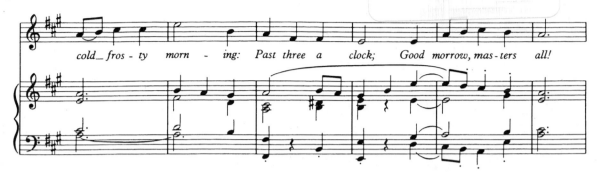

cold_ fros - ty morn - ing: Past three a clock; Good morrow, mas - ters all!

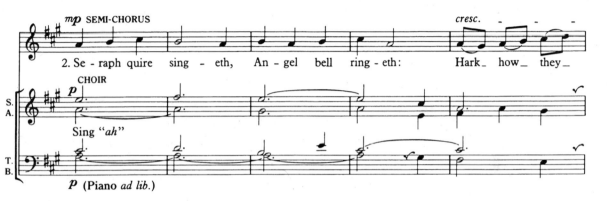

mp SEMI-CHORUS *cresc.*

2. Se - raph quire sing - eth, An - gel bell ring - eth: Hark_ how_ they_

CHOIR
S.
A.
Sing "*ah*"
T.
B.
p (Piano *ad lib.*)

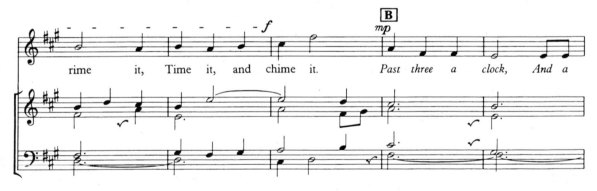

rime it, Time it, and chime it. Past three a clock, And a

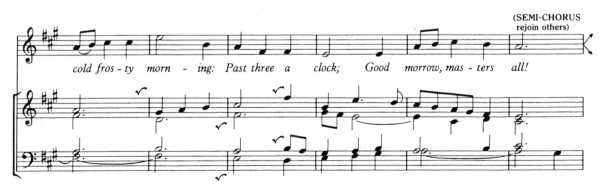

(SEMI-CHORUS
rejoin others)

cold fros - ty morn - ing: Past three a clock; Good morrow, mas - ters all!

4

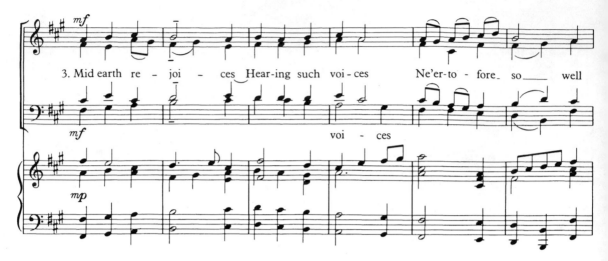

3. Mid earth re - joi - ces Hear-ing such voi-ces Ne'er-to-fore so___ well

voi - ces

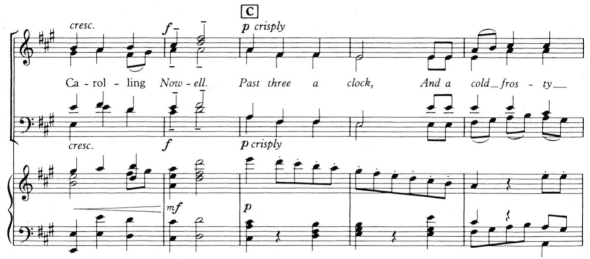

Ca - rol - ling Now - ell. Past three a clock, And a cold__ fros - ty__

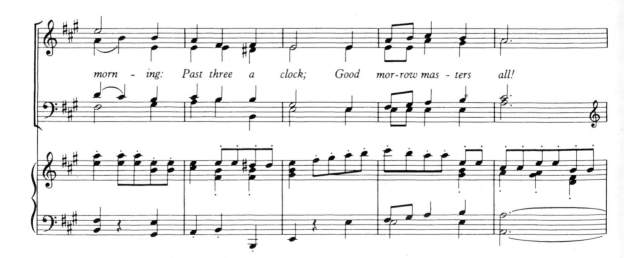

morn - ing: Past three a clock; Good mor-row mas - ters all!

OXFORD

Twelve Christmas Carols

in two sets

SET 2

Past three a clock
Away in a manger
Gabriel's Message
Noel nouvelet
Sans Day Carol
The coming of our King

arranged for mixed voices and orchestra
or piano by

John Rutter

TWELVE CHRISTMAS CAROLS

arranged by JOHN RUTTER

SET 2

1. PAST THREE A CLOCK

G. R. Woodward
(refrain traditional)

English traditional carol

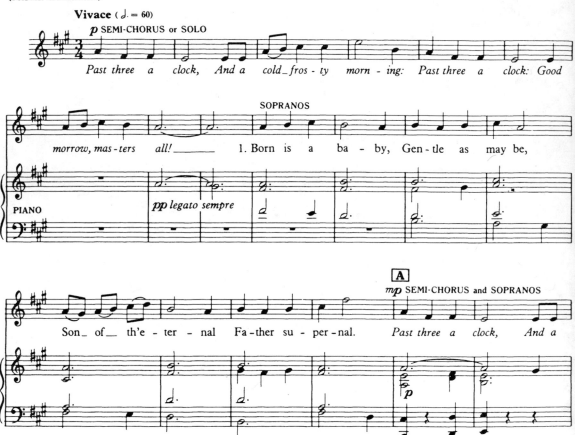

Set 1: *Here we come a-wassailing; The Infant King; Shepherds' Noel; Quittez, pasteurs; Stille Nacht; O come, O come Immanuel*

The twelve carols have been recorded by the Clare College Singers and Orchestra on HMV CLP/CSD 3670 (for release in 1970).

Orchestral scores and parts are on hire.

Note: Piano accompaniments are not always identical with their orchestral counterparts.

Instrumentation for *Past three a clock*: 2 flutes, 2 oboes, bassoon, 2 horns, percussion (1 player), harp (opt.), and strings

Also on sale: *Eight Christmas Carols* arranged by John Rutter, in 2 sets, recorded by the Clare College Singers and Orchestra on HMV CLP/CSD 3634

The words of *Past three a clock* are from *The Cambridge Carol Book* and are reprinted by kind permission of the S.P.C.K.

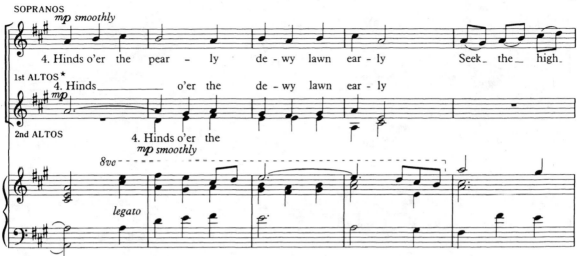

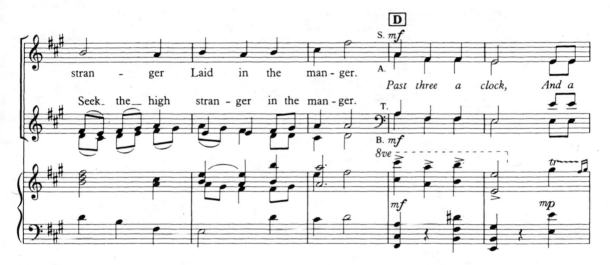

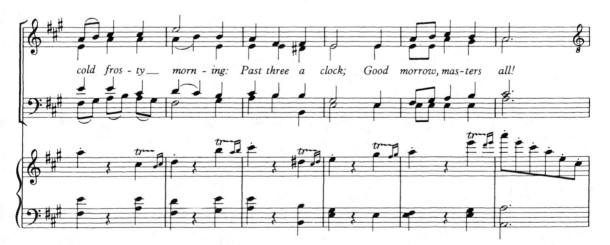

★or 2nd sopranos

Twelve Christmas Carols (Set II)

6

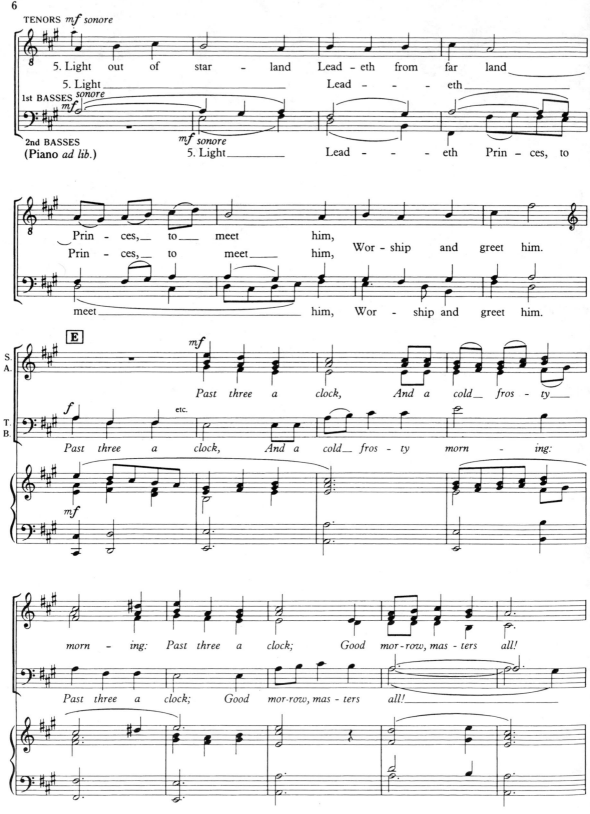

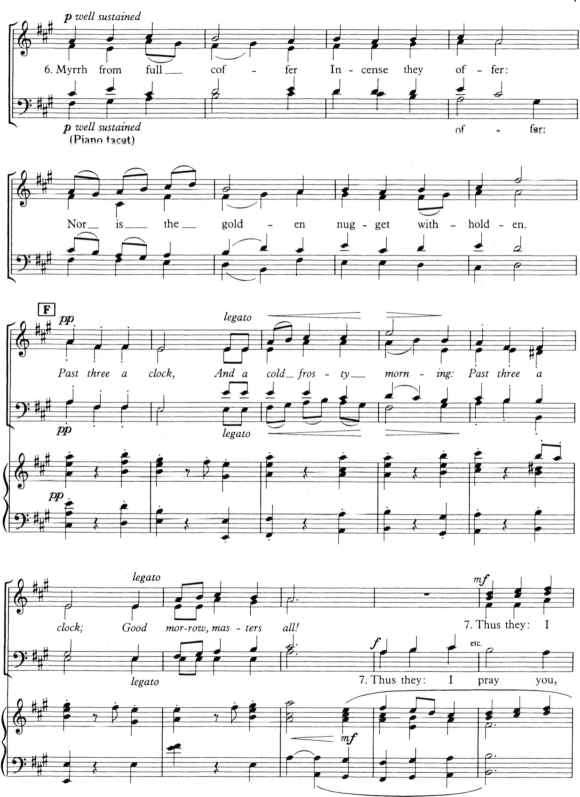

Twelve Christmas Carols (Set II)

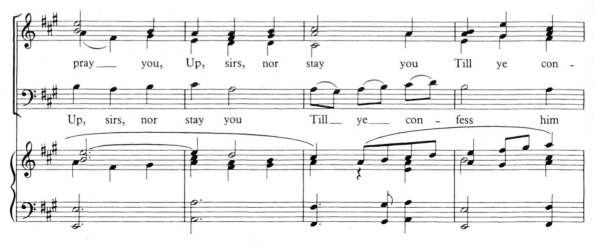

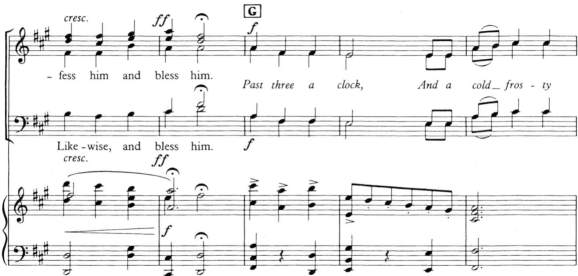

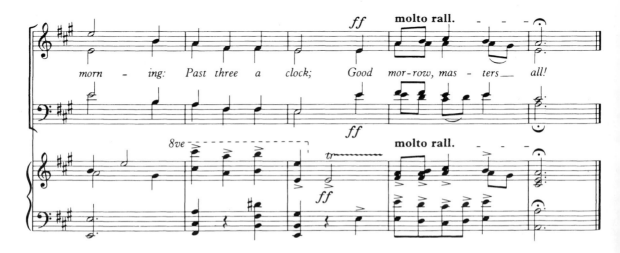

2. AWAY IN A MANGER

Words anon.

W. J. Kirkpatrick

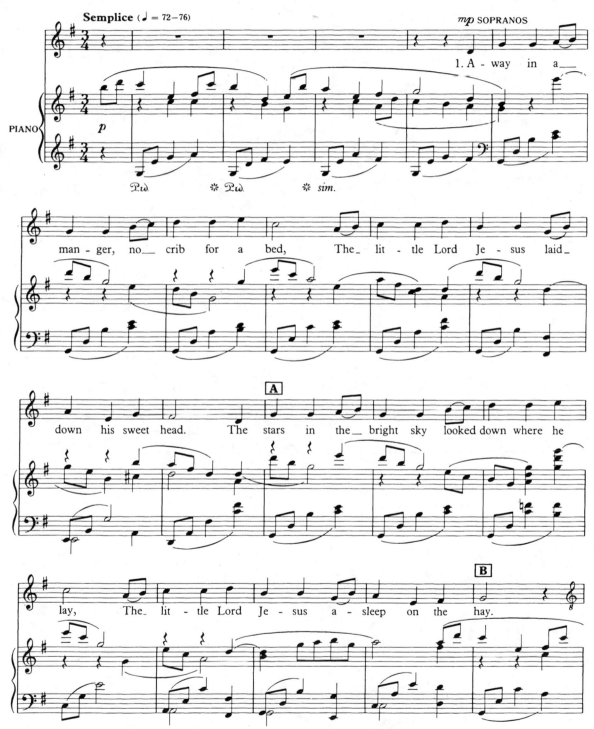

Instrumentation: Flute, oboe, bassoon, 2 horns, harp, and strings

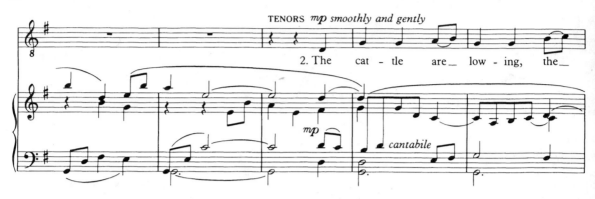

TENORS *mp smoothly and gently*

2. The cat-tle are_ low-ing, the_

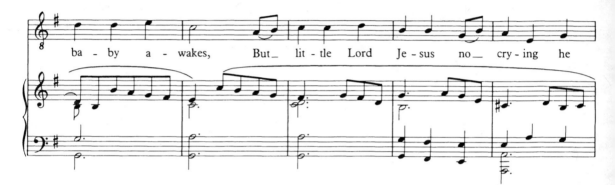

ba-by a-wakes, But_ lit-tle Lord Je-sus no_ cry-ing he

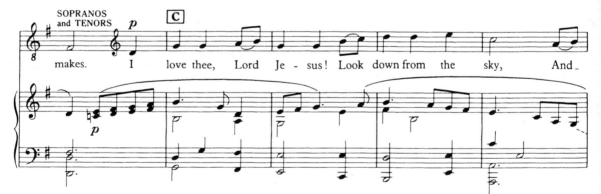

SOPRANOS and TENORS *p* **C**

makes. I love thee, Lord Je-sus! Look down from the sky, And_

D

stay by my side un-til_ morn-ing is nigh.

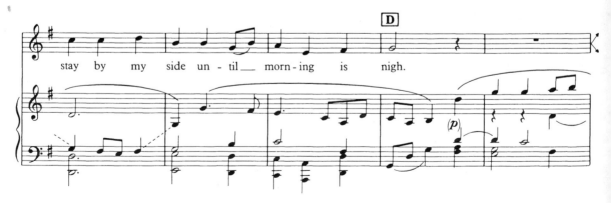

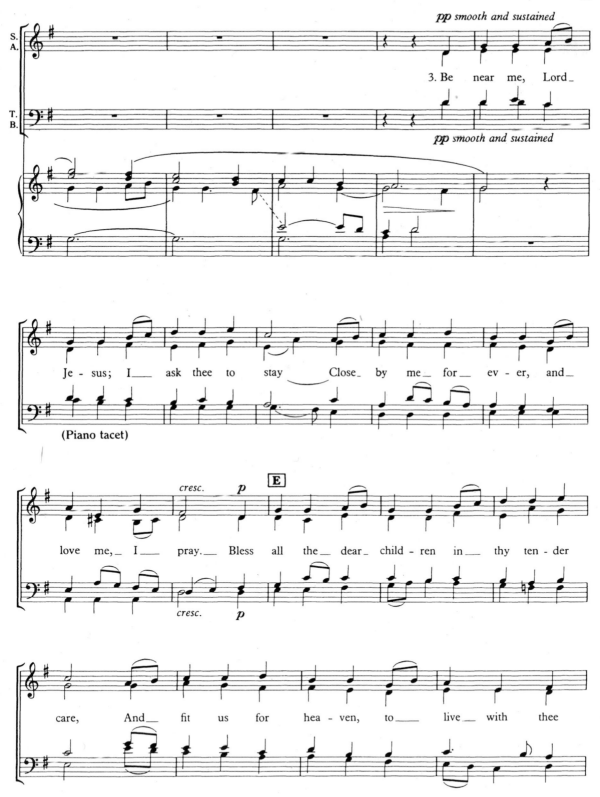

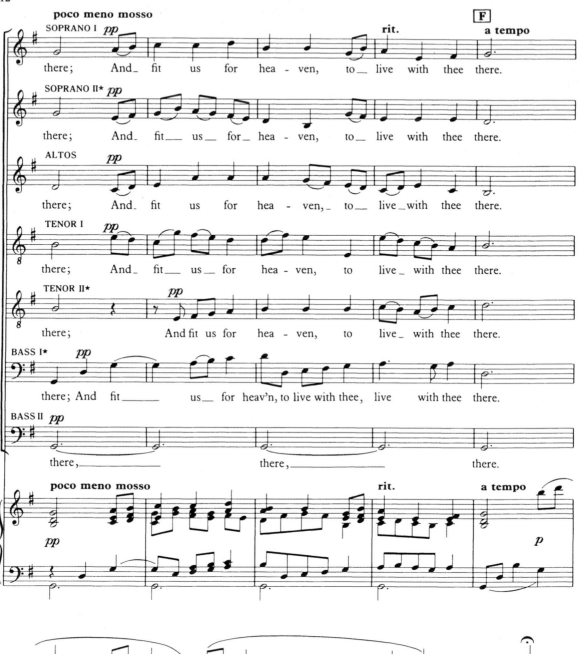

*If absolutely necessary, these parts may be omitted

3. GABRIEL'S MESSAGE

S. Baring-Gould

Basque carol

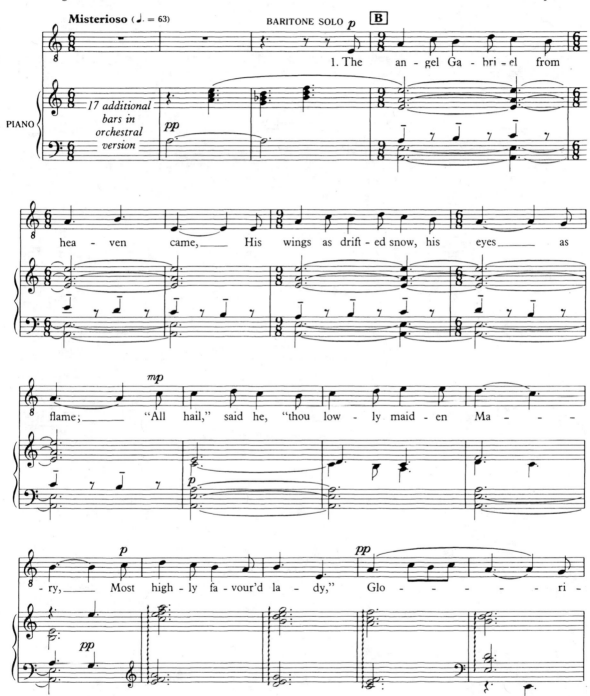

Melody and words reprinted by permission of H. Freeman & Co.
Instrumentation: Flute (doubling piccolo), 2 oboes, bassoon, 2 horns, harp, and strings

14

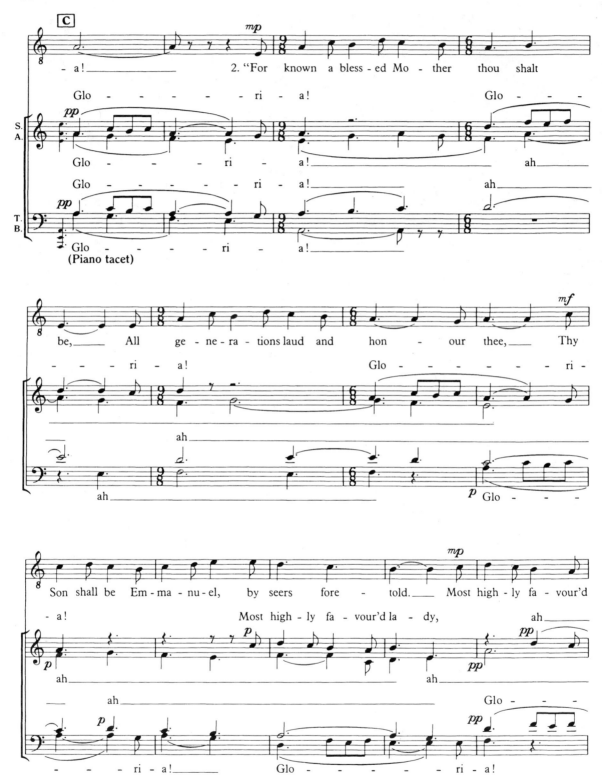

(Piano tacet)

Twelve Christmas Carols (Set II)

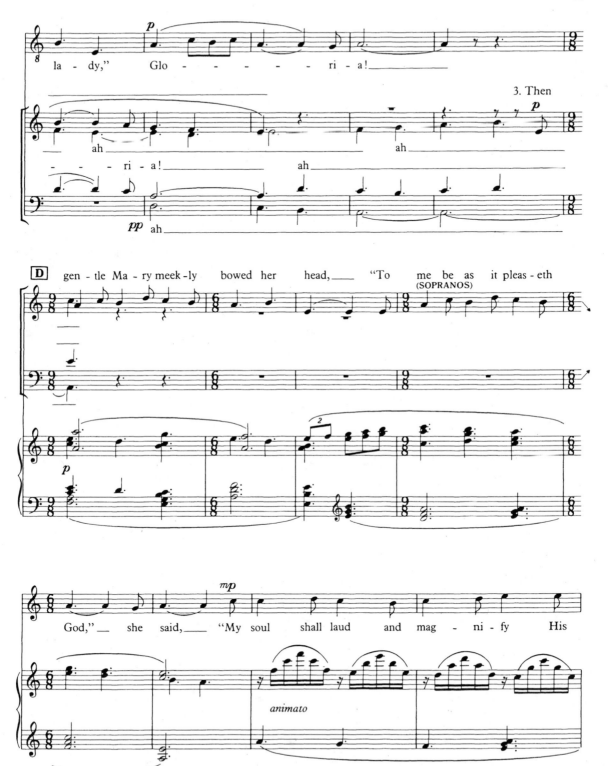

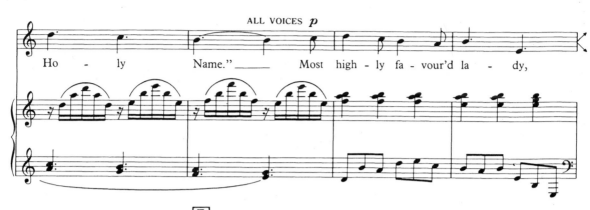

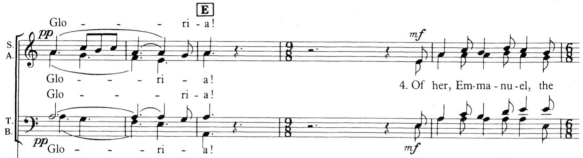

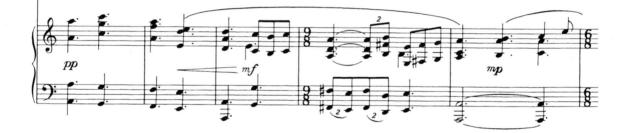

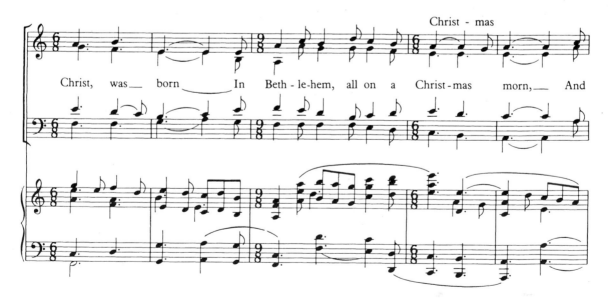

Twelve Christmas Carols (Set II)

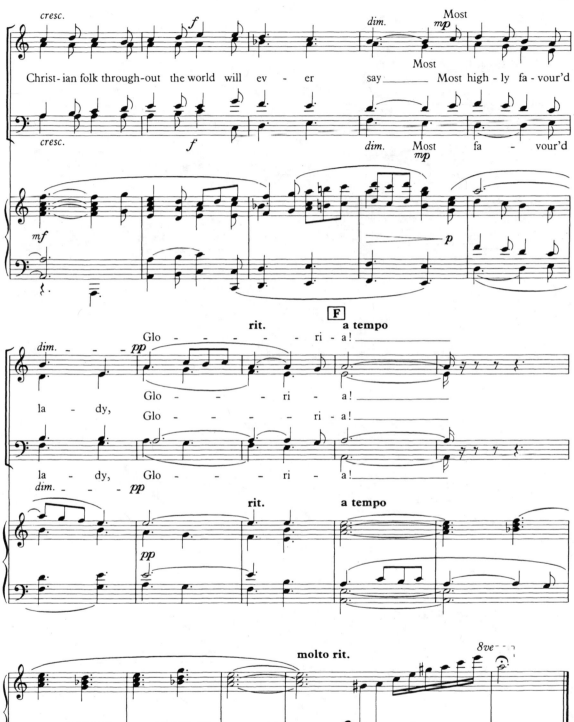

Christ-ian folk through-out the world will ev - er say___ Most high-ly fa-vour'd

la - dy, Glo - ri - a!

4. NOËL NOUVELET

(Nowell, sing nowell)

English words J. R.

French traditional carol

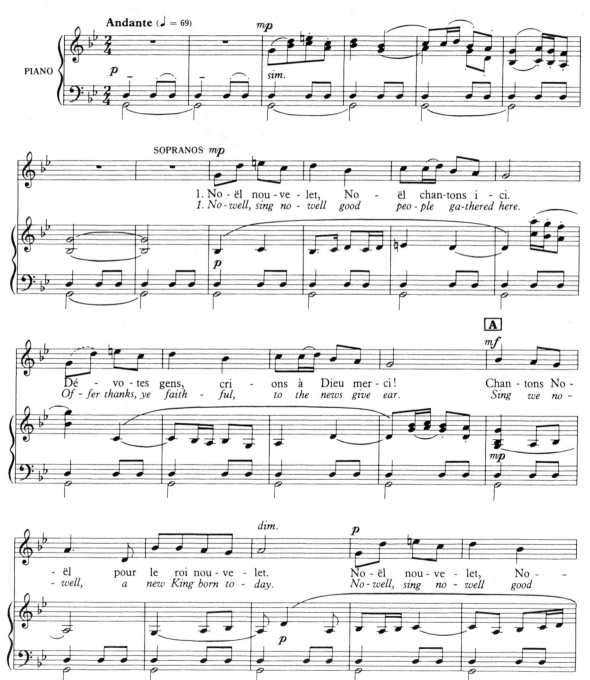

Instrumentation: 2 flutes, oboe, cor anglais, bassoon, 2 horns, and strings

TENORS *mf smoothly*

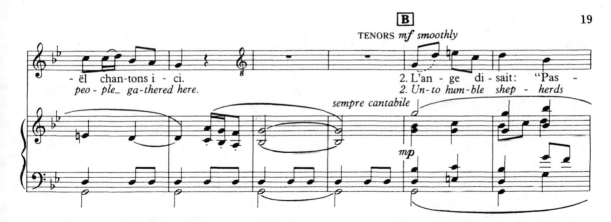

-ël chan-tons i - ci.
peo - ple_ ga-thered here.

2. L'an - ge di - sait: "Pas -
2. Un-to hum-ble shep - herds

sempre cantabile

mp

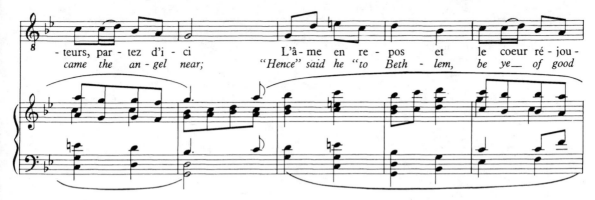

-teurs, par - tez d'i - ci
came the an - gel near;

L'â-me en re - pos et le coeur ré - jou -
"Hence" said he "to Beth - lem, be ye_ of good

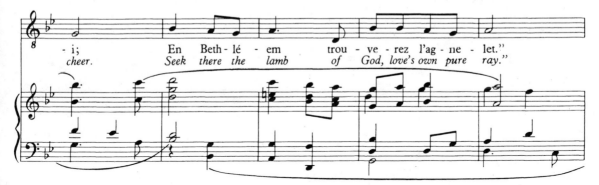

- i;
cheer.

En Beth - lé - em trou - ve - rez l'ag - ne - let."
Seek there the lamb of God, love's own pure ray."

poco rall. a tempo

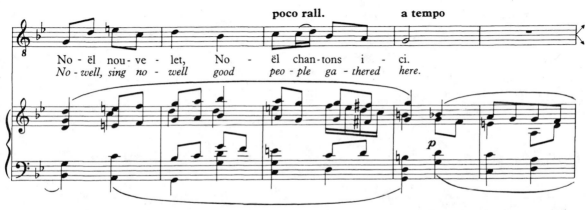

No - ël nou - ve - let, No - ël chan-tons i - ci.
No - well, sing no - well good peo - ple ga - thered here.

p

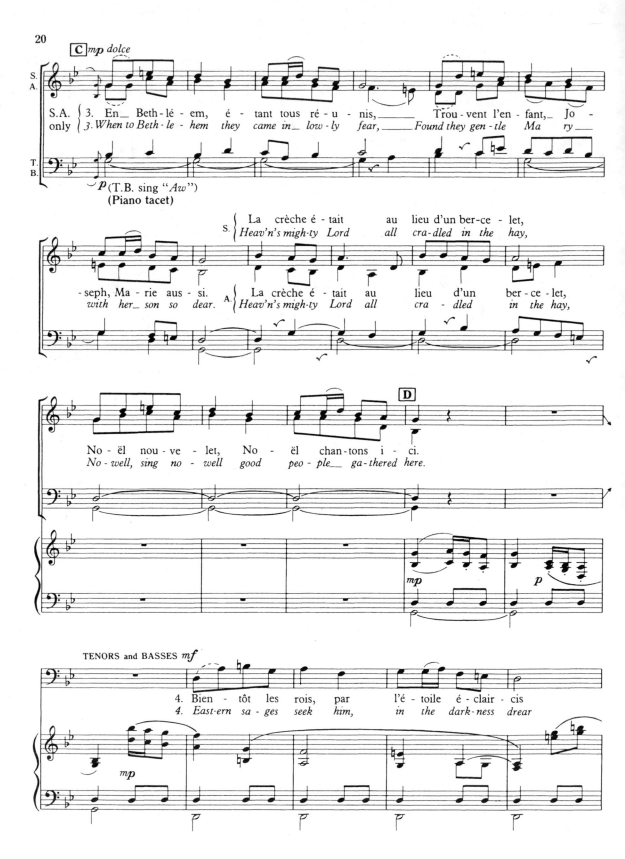

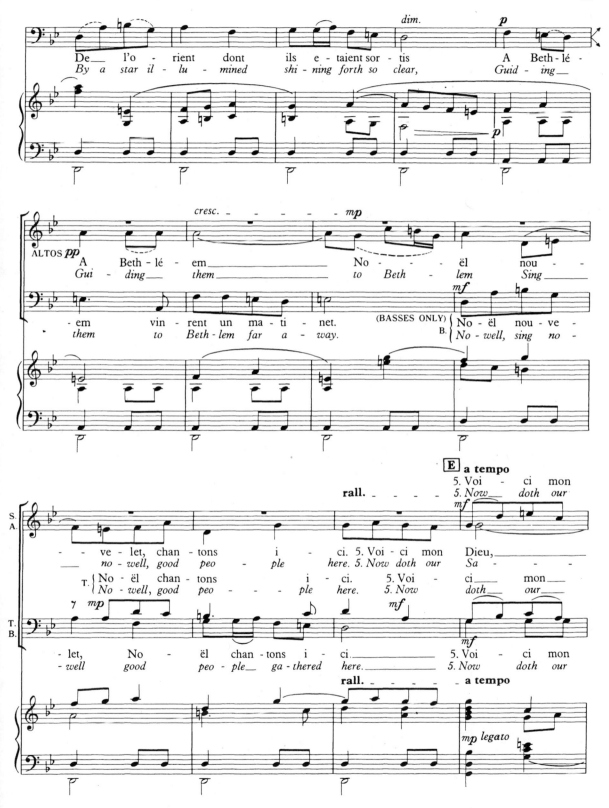

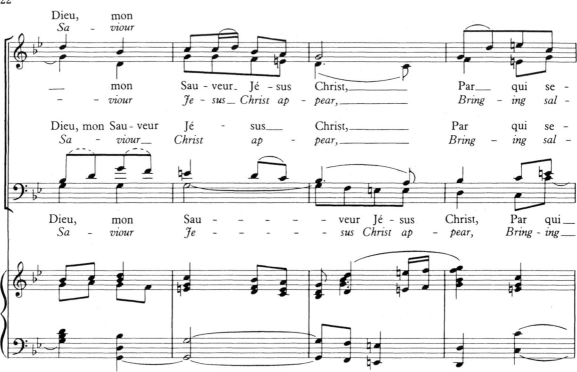

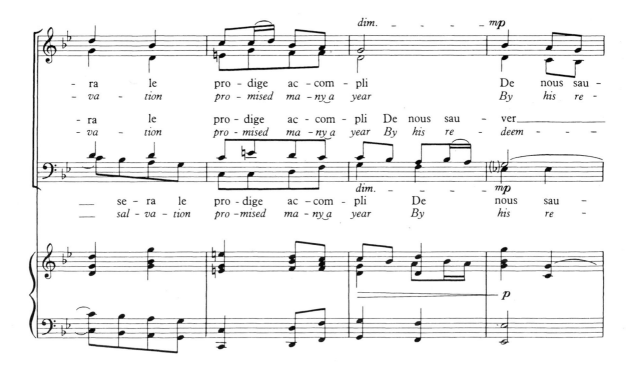

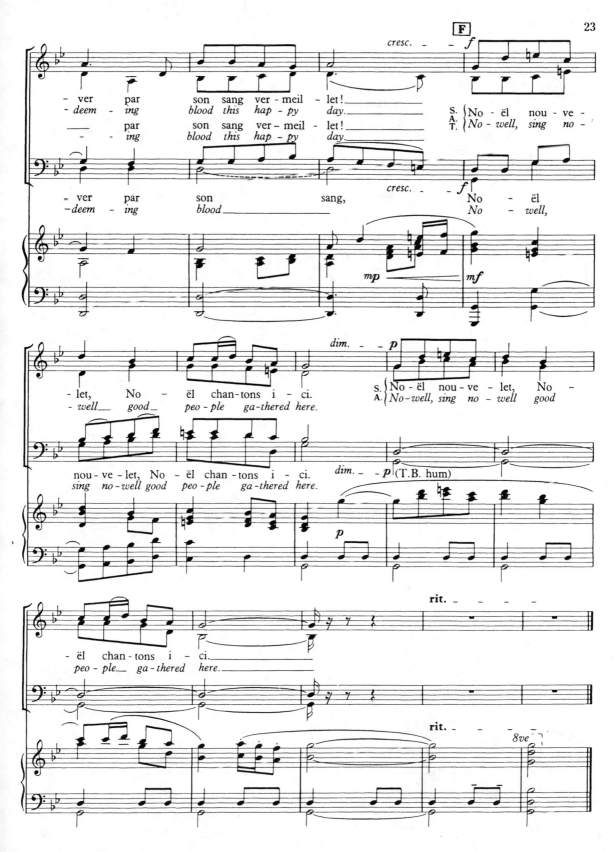

5. SANS DAY CAROL

Cornish traditional carol

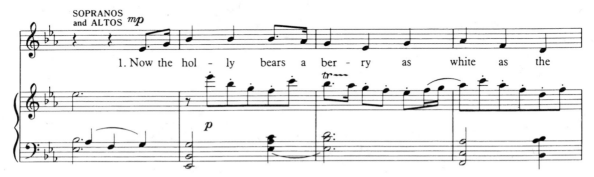

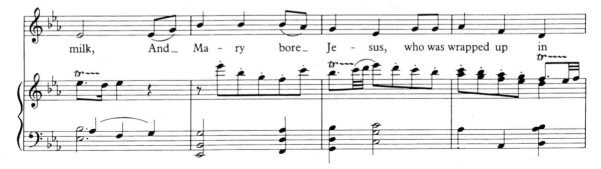

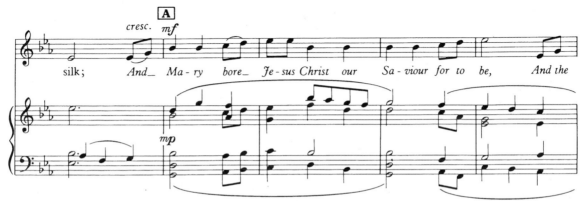

Words collected by Percy Dearmer and used by permission of Oxford University Press
Instrumentation: 2 flutes (1 doubling piccolo), 2 oboes, bassoon, 2 horns, and strings.

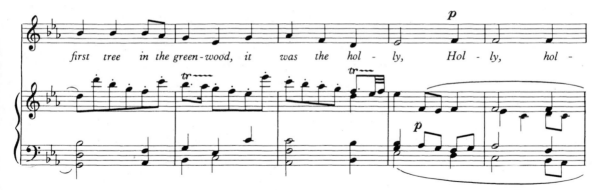

first tree in the green-wood, it was the hol - ly, Hol - ly, hol -

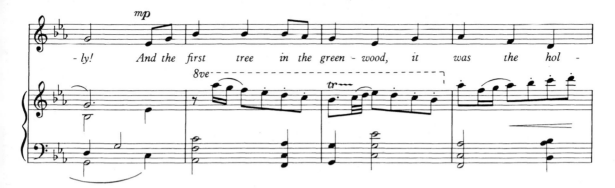

- ly! And the first tree in the green - wood, it was the hol -

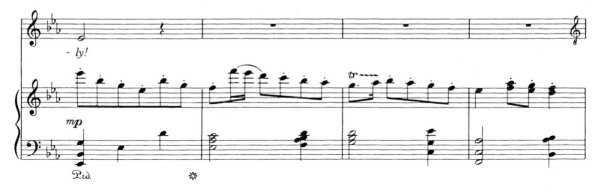

- ly!

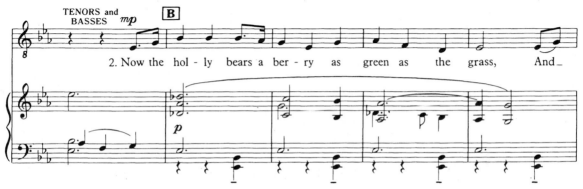

TENORS and BASSES

B

2. Now the hol - ly bears a ber - ry as green as the grass, And_

Twelve Christmas Carols (Set II)

ALL VOICES

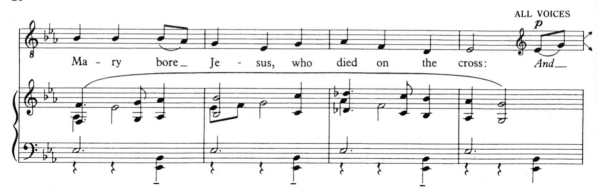

Ma - ry bore_ Je - sus, who died on the cross: And_

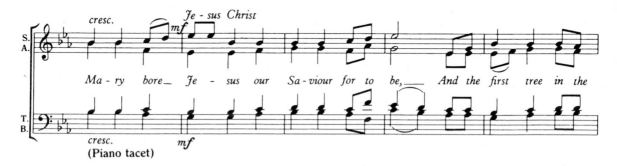

Je - sus Christ

Ma - ry bore_ Je - sus our Sa - viour for to be,_ And the first tree in the

cresc. mf

(Piano tacet)

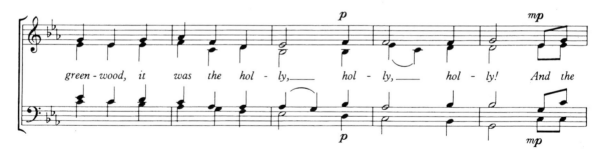

green - wood, it was the hol - ly,_ hol - ly,_ hol - ly! And the

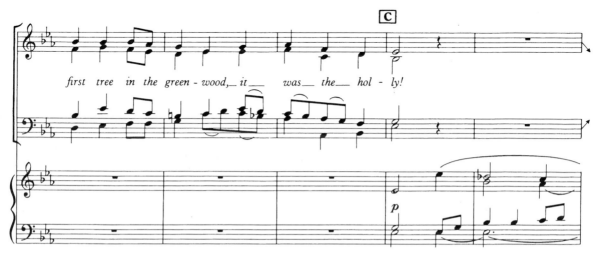

first tree in the green - wood, it_ was_ the_ hol - ly!

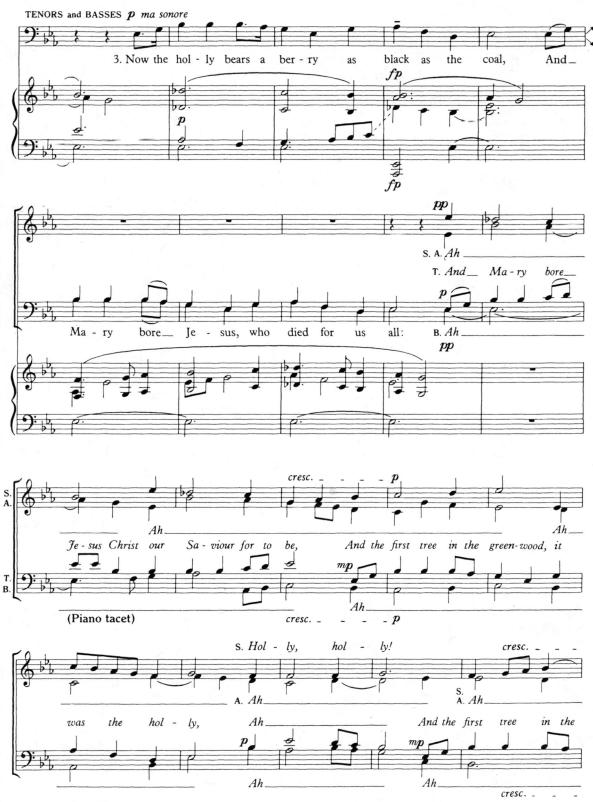

TENORS and BASSES *p ma sonore*

3. Now the hol - ly bears a ber - ry as black as the coal, And

S. A. *Ah*

T. *And Ma - ry bore*

Ma - ry bore Je - sus, who died for us all: B. *Ah*

Je - sus Christ our Sa - viour for to be, And the first tree in the green-wood, it

Ah *Ah*

Ah

(Piano tacet)

S. *Hol - ly, hol - ly!*

A. *Ah* S. A. *Ah*

was the hol - ly, *Ah* And the first tree in the

Ah *Ah*

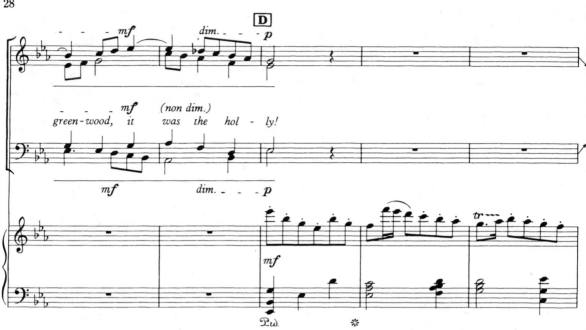

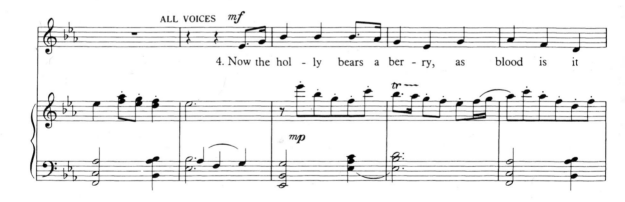

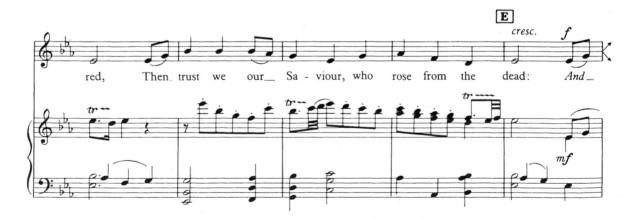

Twelve Christmas Carols (Set II)

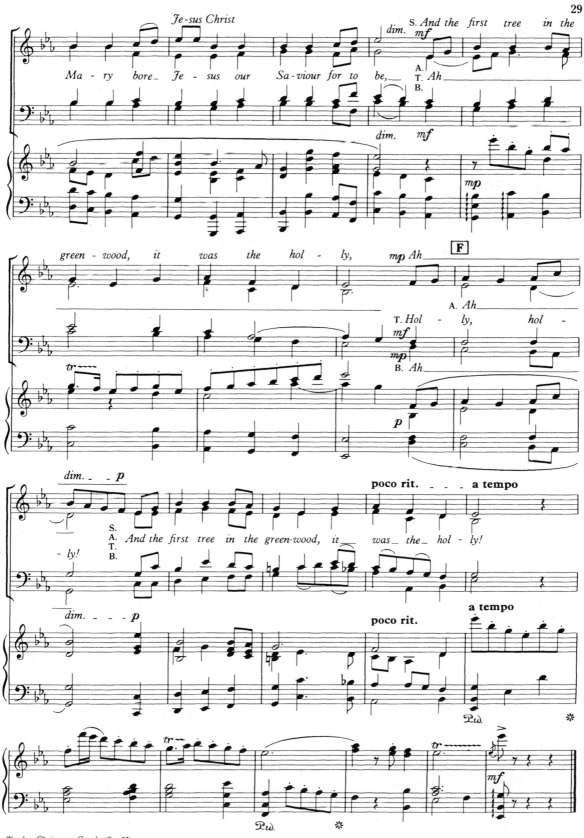

Twelve Christmas Carols (Set II)

6. THE COMING OF OUR KING

Words anon.

Polish traditional carol

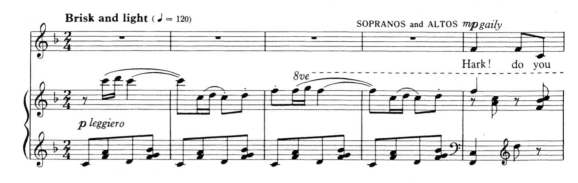

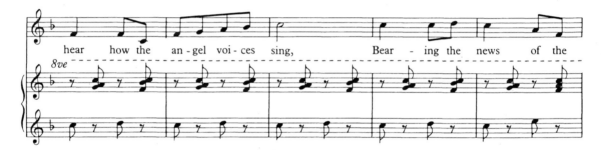

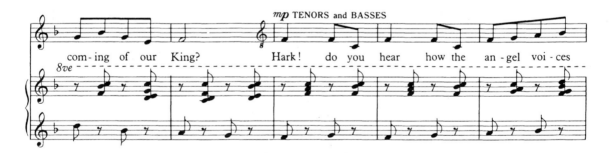

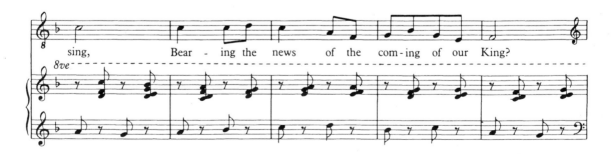

Instrumentation: 2 flutes, 2 oboes, bassoon, 2 horns, glockenspiel, harp (opt.), and strings

A *mf* ALL VOICES

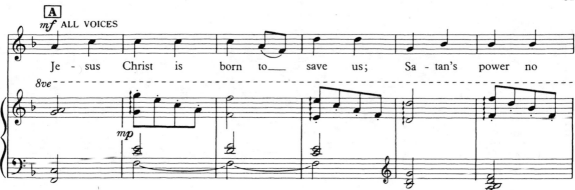

Je - sus Christ is born to__ save us; Sa - tan's power no

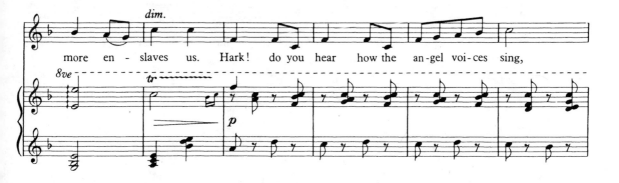

more en - slaves us. Hark! do you hear how the an - gel voi - ces sing,

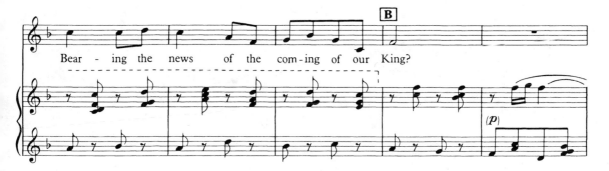

Bear - ing the news of the com - ing of our King? **B**

TENORS and BASSES *mf crisply*

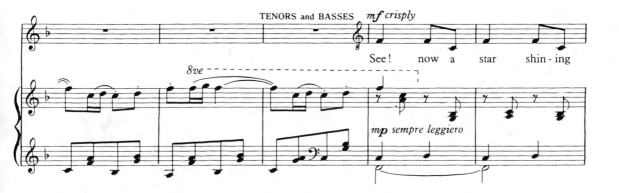

See! now a star shin - ing

Twelve Christmas Carols (Set II)

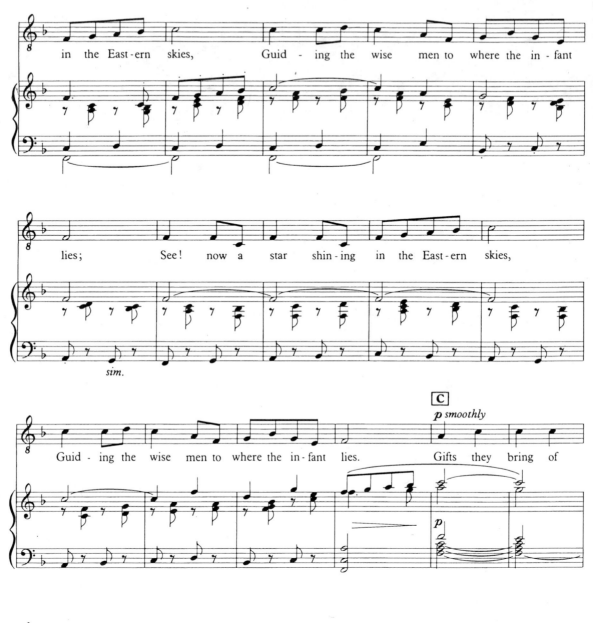

in the East-ern skies, Guid - ing the wise men to where the in - fant

lies; See! now a star shin - ing in the East-ern skies,

sim.

C

p smoothly

Guid - ing the wise men to where the in - fant lies. Gifts they bring of

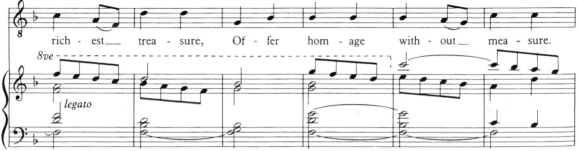

rich - est___ trea - sure, Of - fer hom - age with - out___ mea - sure.

8ve

legato

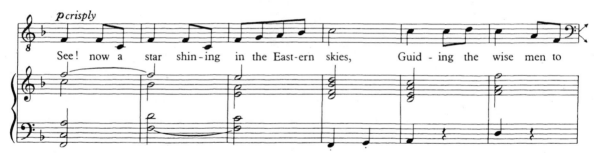

See! now a star shin-ing in the East-ern skies, Guid-ing the wise men to

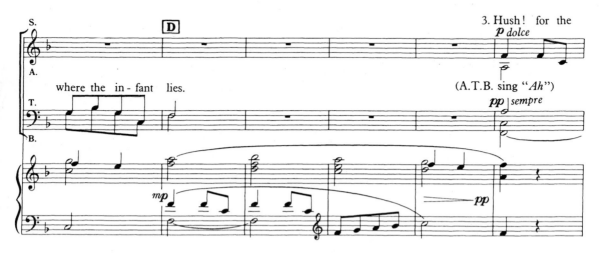

where the in-fant lies.

3. Hush! for the

(A.T.B. sing "Ah")

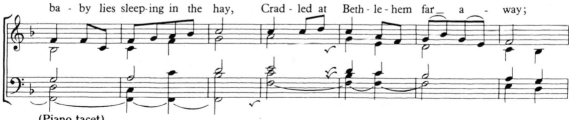

ba - by lies sleep-ing in the hay, Crad-led at Beth-le-hem far_ a - way;

(Piano tacet)

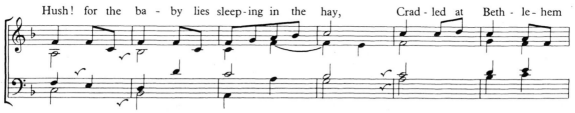

Hush! for the ba - by lies sleep-ing in the hay, Crad-led at Beth-le-hem

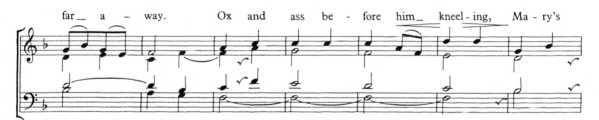

far_ a - way. Ox and ass be - fore him_ kneel-ing, Ma - ry's

Twelve Christmas Carols (Set II)

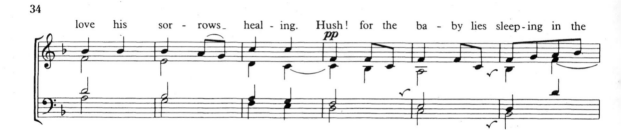

love his sor-rows_ heal-ing. Hush! for the ba-by lies sleep-ing in the

pp

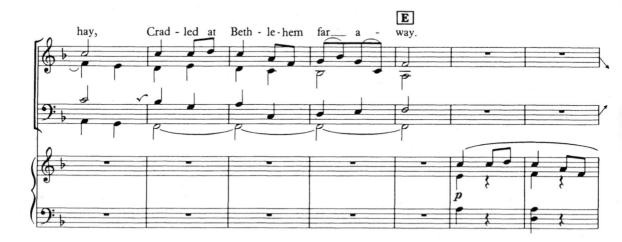

hay, Crad-led at Beth-le-hem far__ a-way.

E

ALL VOICES *mp crisp and rhythmic*

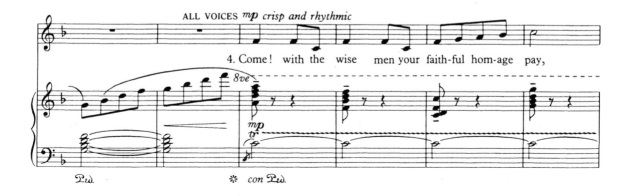

4. Come! with the wise men your faith-ful hom-age pay,

mp

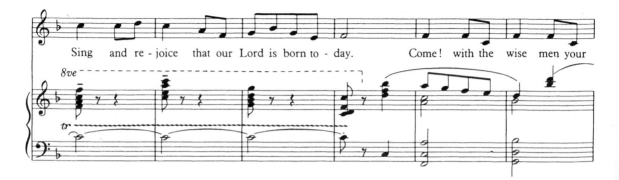

Sing and re-joice that our Lord is born to-day. Come! with the wise men your

Twelve Christmas Carols (Set II)

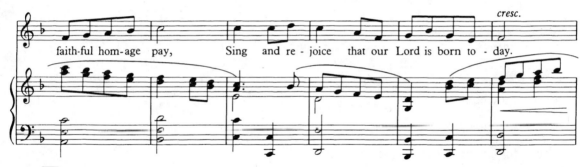

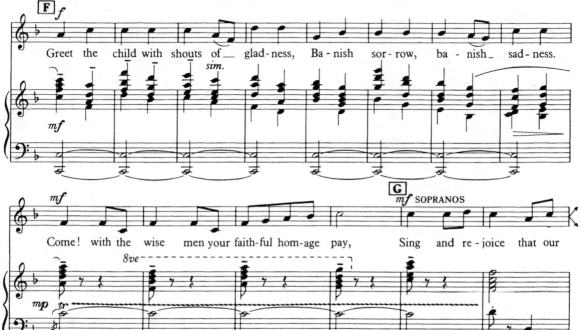

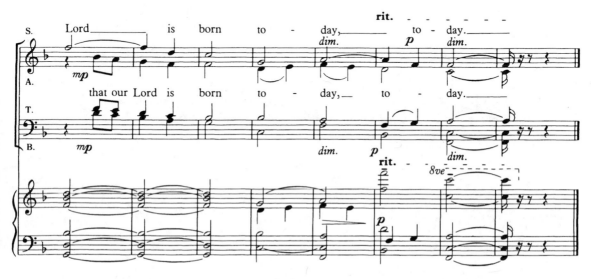

OXFORD UNIVERSITY PRESS

OXFORD CHRISTMAS COLLECTIONS

100 Carols for Choirs
edited and arranged by David Willcocks and John Rutter

Carols for Choirs 1

Carols for Choirs 2

Carols for Choirs 3

Carols for Choirs 4 (upper voices)

The New Oxford Book of Carols
201 carols, supplemented with extensive notes on historical background and performance, edited by Hugh Keyte and Andrew Parrott. Available in hardback and paperback.

The Shorter New Oxford Book of Carols
122 carols selected from *The New Oxford Book of Carols*, edited by Hugh Keyte and Andrew Parrott

Oxford Choral Classics: Christmas Motets
Sixteen motets selected and edited by John Rutter

The Oxford Book of Carols
197 carols edited by Percy Dearmer, Ralph Vaughan Williams, and Martin Shaw

A Little Carol Book
Fifteen Christmas carols and hymns arranged for mixed voices by John Rutter
Not for sale in the USA

Eight Christmas Carols
in two sets, arranged for mixed voices and small orchestra or piano by John Rutter

Six Carols with Descants
arranged for mixed voices and organ by Philip Ledger

Twelve Christmas Carols
in two sets, arranged for mixed voices and small orchestra or piano by John Rutter

Please write for our catalogue of Oxford Christmas Music which details carol collections for schools, carol orchestrations, individual carols, and other music for Christmas including choral works, nativity plays, and instrumental music.

OXFORD
UNIVERSITY PRESS

www.oup.com

ISBN 978-0-19-385022-4

9 780193 850224